T0271609

REVISED EDITION

STICKERBOMB 2

LAURENCE KING

First published in Great Britain in 2010 by Laurence King Publishing Ltd
This edition published in 2024 by Laurence King, an imprint of
The Orion Publishing Group Ltd, Carmelite House,
50 Victoria Embankment, London EC4Y 0DZ

An Hachette UK Company

10 9 8 7 6 5 4 3 2 1

A CIP catalogue record for this book is available from the British Library

ISBN: 978-1-39962-068-0

Research and edit by Suridh Hassan and Ryo Sanada of Soi Books.
Designed and typeset by Soi Books.
Title font: JF Rock. © Jester Font Studio.
Main font : Basic Sans © Latinotype.

www.stickerbombworld.com
www.soibooks.com

Origination by f1 Colour
Printed in China by Leo Paper Products

MIX
Paper | Supporting
responsible forestry
FSC® C104740

www.laurenceking.com
www.orionbooks.co.uk

2

STICKERBOMB

★ SOI BOOKS ★

Laurence King

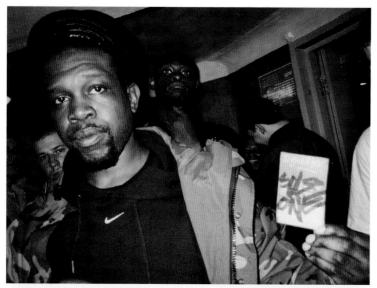

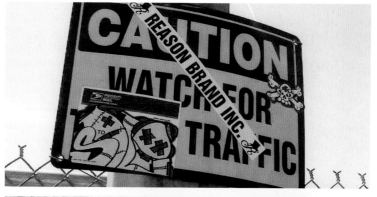

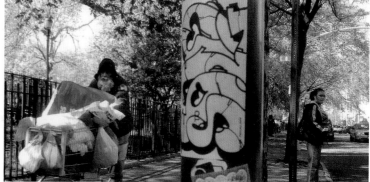

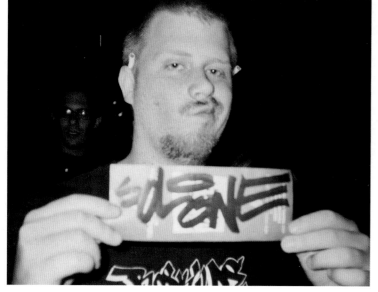

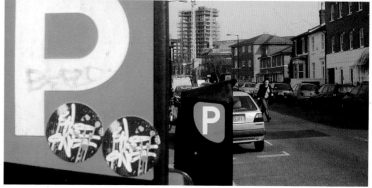

Clockwise from top left: Jeru the Damaja, New York, New York, London, EL-P

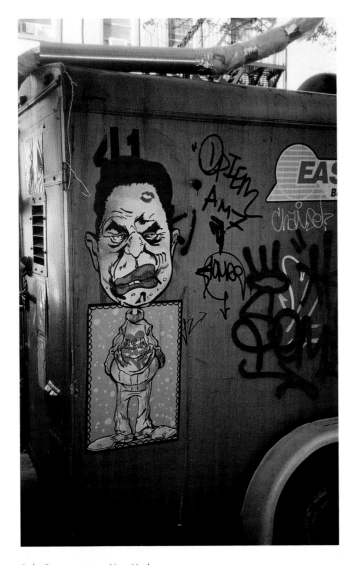

Solo One paste up, New York.

SOLO ONE
London, UK

When you make art it feels like a fight with those who don't do it or understand it. Your journey as an artist will take you across many mediums and surfaces. My sticker project began in 1997. The idea was to get up across the city of London as much as possible using stickers as my medium. Travelling across the city day and night was a way of feeling what it was about and I could see the beauty and the ugliness sometimes at the same time.

I believe in taking public space away from the corporations who have totally dominated all outdoor advertising space. The streets are not theirs; they are ours. I also believe in the old graffiti tradition of 'getting up'. Going all city is hard and time-consuming, and when you produce something handmade and put it out there it says a lot about you. My sticker journey led me to make new friends and enemies, and came to a halt when I'd put out nearly a million Royal Mail 'signed for' stickers and the Post Office were forced to withdraw printed stickers. Pushing creativity is what we should all be doing. Hip-hop culture teaches us to be creative, visionary and to express ourselves. I hope the readers and sticker collectors feel inspired to make and create a journey for themselves and give love to the streets worldwide.

JEFF JANK
USA

Sticker High & Low Points

I've been drawing and designing and making fun things at Stones Throw Records for nearly ten years now. It's always a thrill to go somewhere new and see a sticker for some project I've done on a pole, or the back of a street sign, or in some stinky bathroom. It's like having a representative of an Underground City Council Greeting Committee approach me on the street and say, 'Hello, friend, anvd welcome.'

The high point of my own sticker sightings was when I travelled to Madrid for the first time – but what I spotted wasn't my own sticker exactly. It was a drawing of mine of the rapper Quasimoto, one made ten years earlier on a napkin in a café. Someone had printed out the drawing from

a CD and made it into a sticker of their own, placing it high up on a wall on the Gran Via. I have friends in this city, I thought. Strangers, secretly communicating.

The low point was going to a Stones Throw event in Los Angeles and seeing the torn-away paper backing of 100 to 200 Stones Throw stickers thrown around in the gutter, leftover trash from stickers we'd given away that night. We love stickers, we love tags, we love graffiti – but trash is just trash. Thrown away paper in the gutter isn't communicating anything except waste. I picked up all the paper and threw it away. Years later, the garbage associated with stickers is still an unsolved concern.

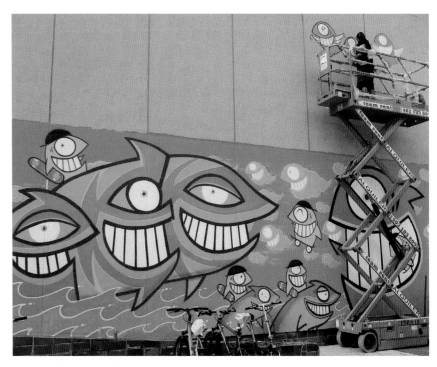

PEZ
Barcelona, Spain

I started to do stickers in 1999 as it was a really good way of putting my work on the streets of Barcelona. I started using stickers to cover schoolbooks, and some friends gave me stickers when they were working in factories putting stickers on boxes. I started hand-painting all my stickers, recycling some brand stickers with white spray paint and painting my fish on new ones. Just now I have some friends who are travelling in India and Colombia and they buy me really cheap stickers.

I like it when people put their stickers on the streets. I love sticker combos, but I don't like it when the stickers cover up other people's tags; if you put up stickers, respect other street artists. I love how people are doing nice letters and good characters using fluoro colours, and putting stickers so high that nobody can remove them.

Darbotz stickers, New York

DARBOTZ
Jakarta, Indonesia

The culture of stickers has existed for ages. I used to collect robots/monsters when I was a kid – mostly from Japanese movies: I remember *Voltes 5, Kamen Rider, Lion Man, Godzilla*, etc. Then came the era of the skateboard; stickers were a must for skaters back in the day. That was probably when I first got interested in making my own stickers.

I used to make a lot of stickers. I think that was the beginning of my interest in street art - stickers were one of my early explorations. I did a lot of characters before I decided to make CUMI. It's so easy to make a sticker: you can print it on your own, go to the print shop or even draw it on sticky paper. I used to paste them around the campus or in the street. Now I only use stickers as merchandise, or my ammo when travelling.

.1

.2

.3

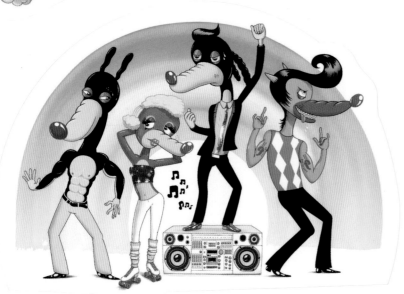

.4

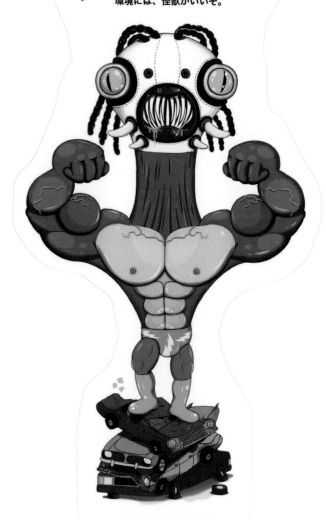

MONSTERS ARE GOOD FOR THE ENVIRONMENT

環境には、怪獣がいいぞ。

.5

.6

.7

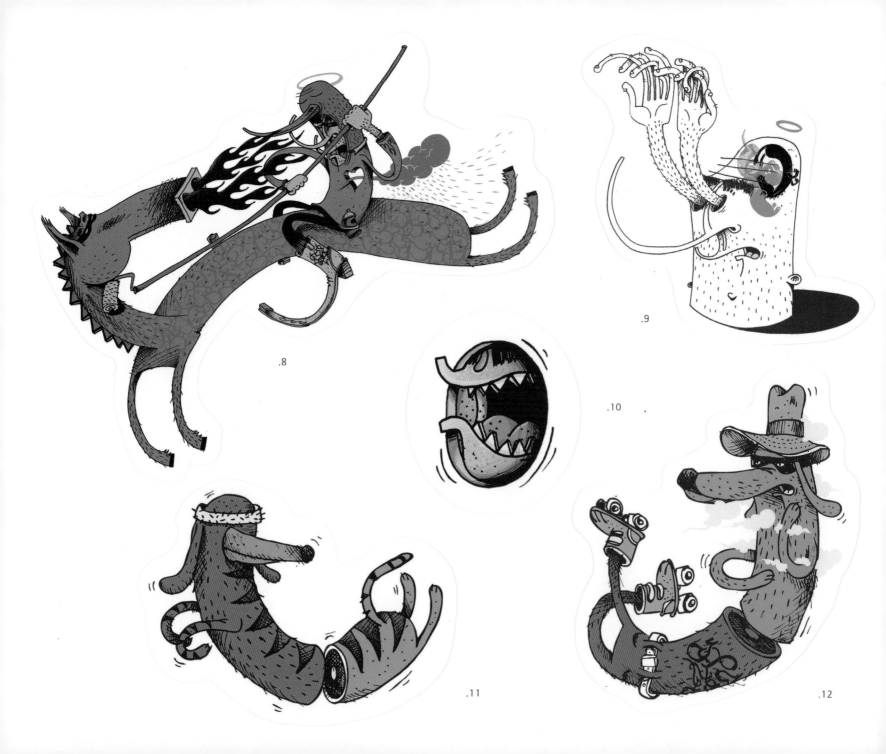

.8

.9

.10

.11

.12

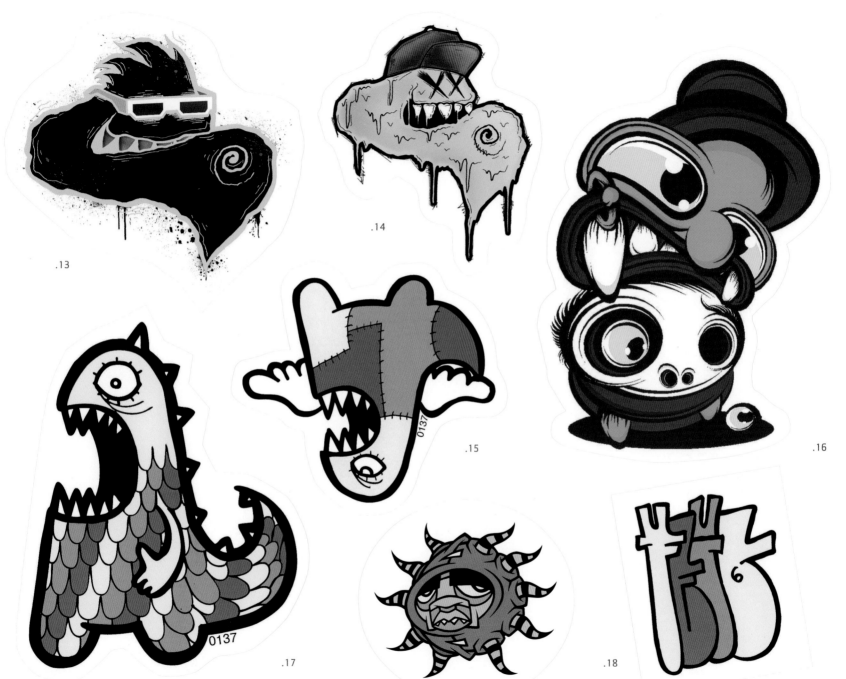

.13

.14

.15

.16

.17

.18

.19

0137

0137

0137

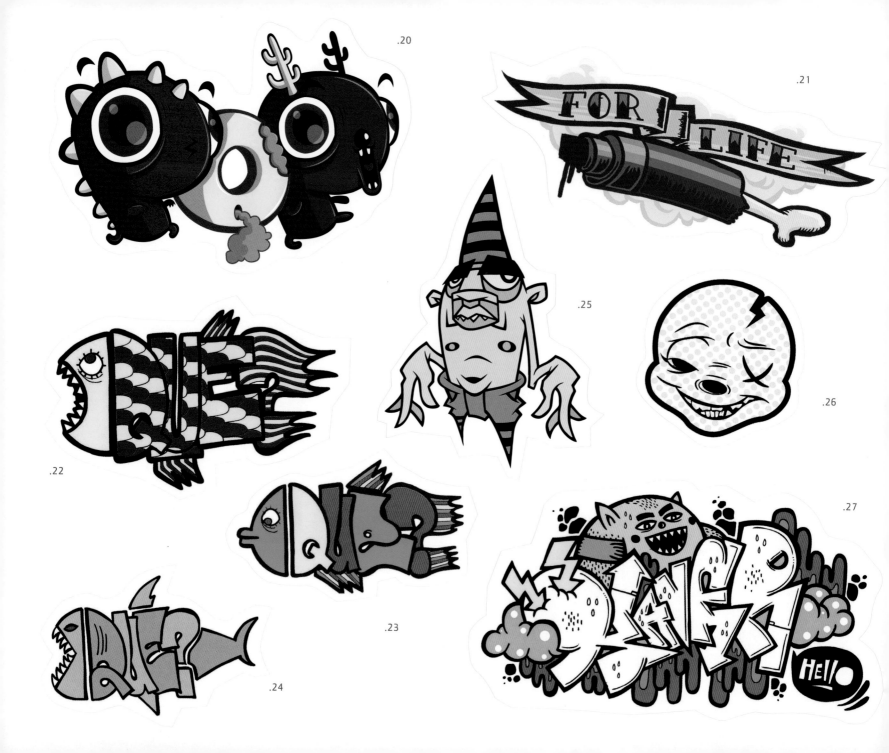

.20

.21

.25

.26

.22

.23

.24

.27

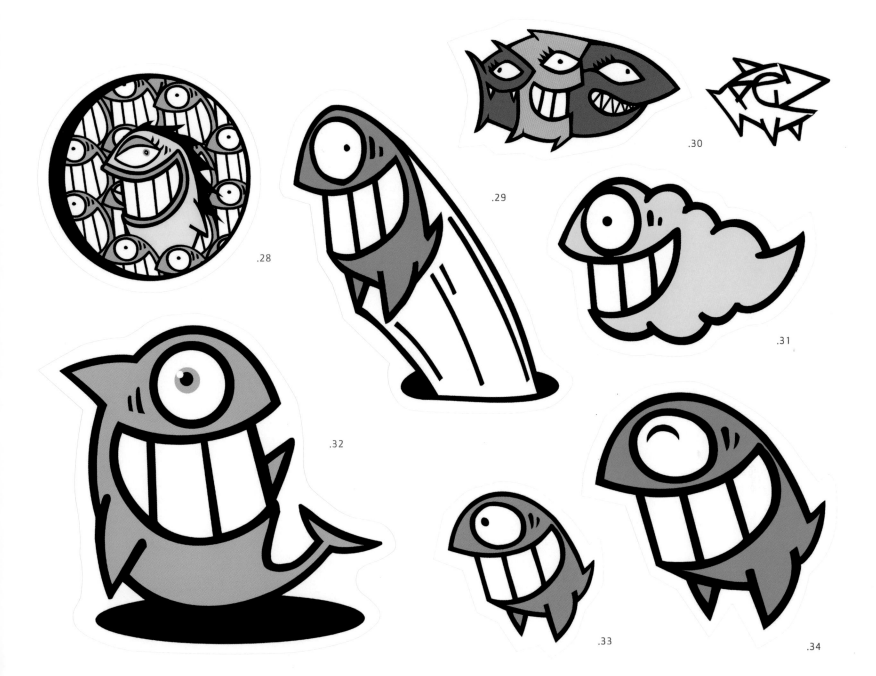

.28

.29

.30

.31

.32

.33

.34

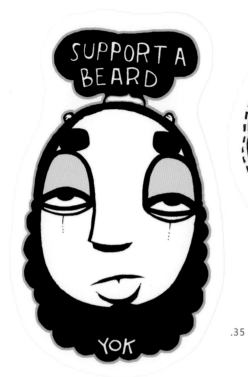

SUPPORT A BEARD

YOK

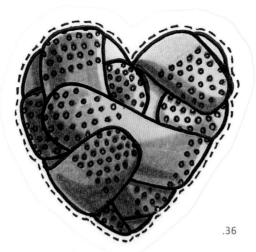

.36

.37

.35

.38

.39

YOKISMO

MOUSTACHE ENVY

.40

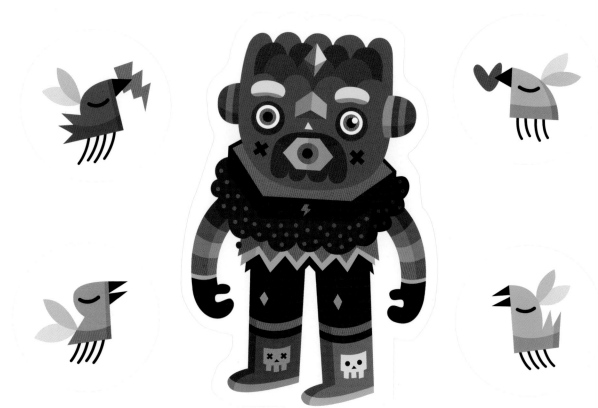

.41

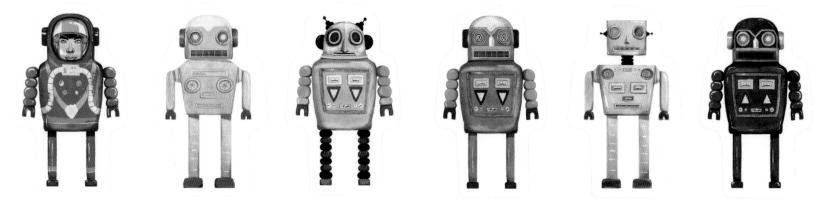

.42

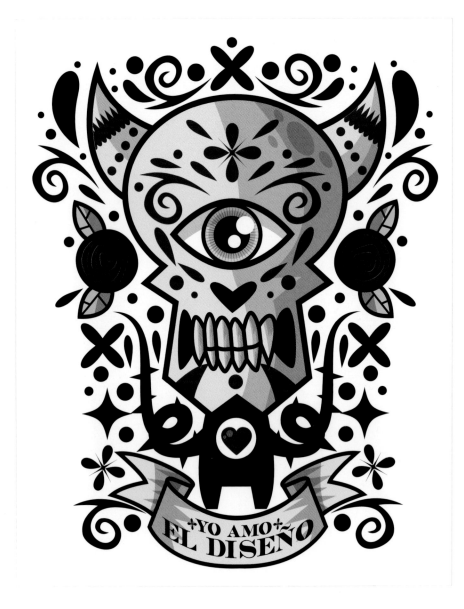

.43

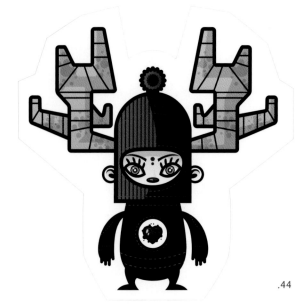

.44

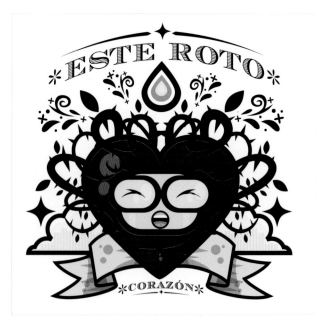

.45

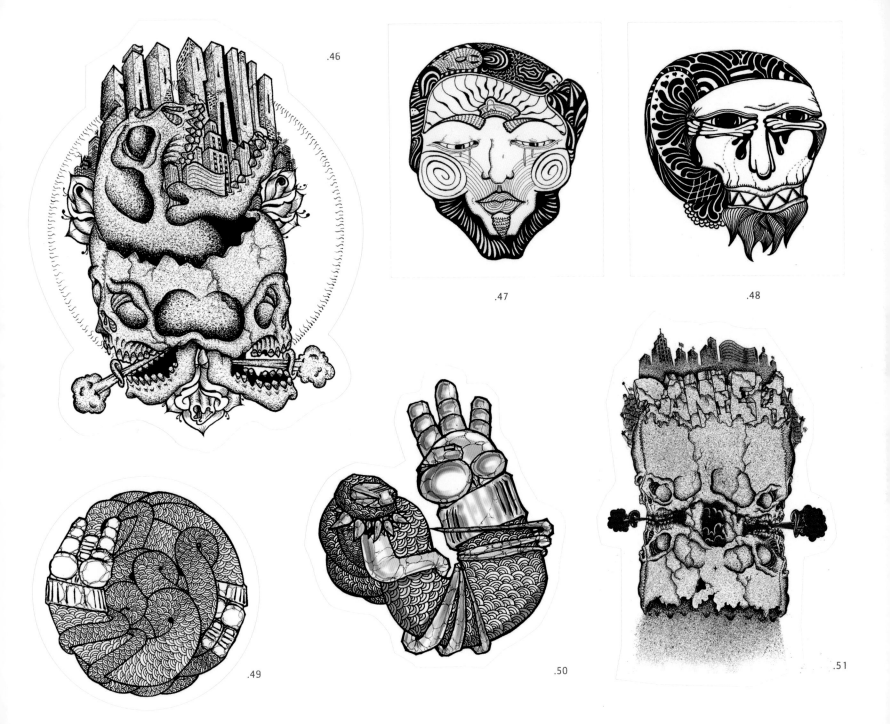

.46

.47

.48

.49

.50

.51

.52

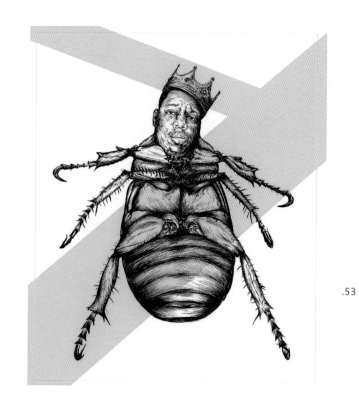

.53

.54

.55

PSHHH.

.56

.57

BUTT SUP

7'4"
420LB
BEEFCAKE

HAS
A
POSSE

.58

.59

MUM

.60

.61

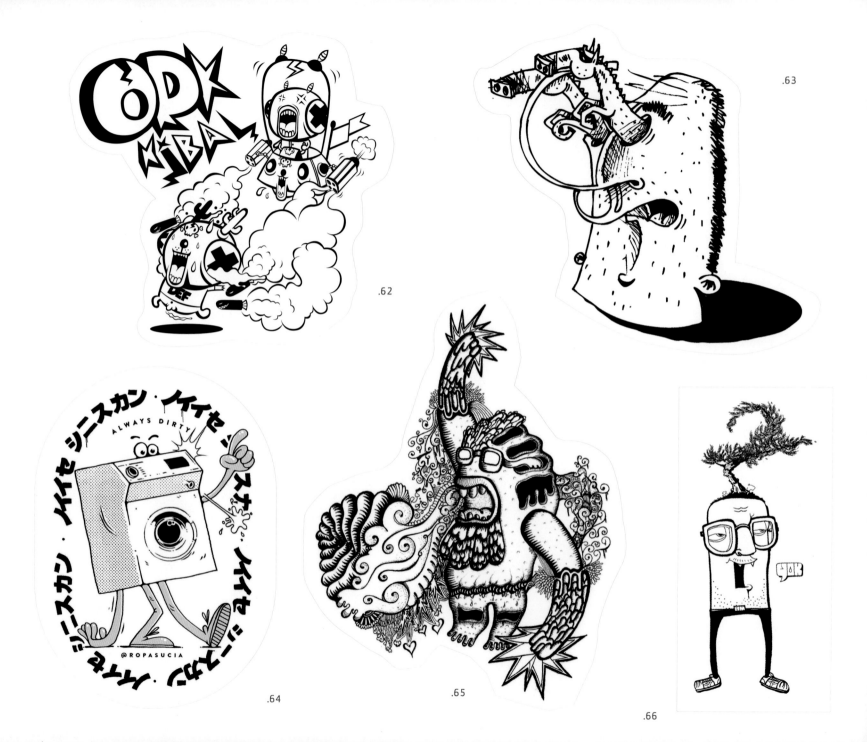

.62

.63

.64

.65

.66

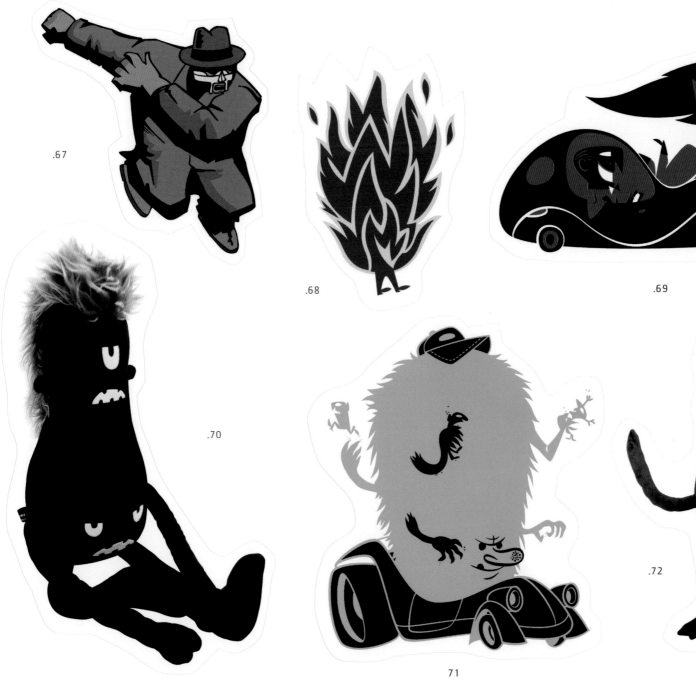

.67

.68

.69

.70

71

.72

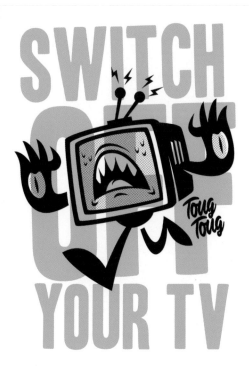

.73

.74

.75

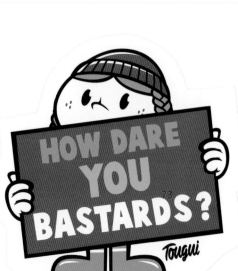

.76

.77

.78

.80

.81

.82

.79

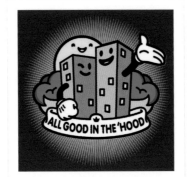

.83

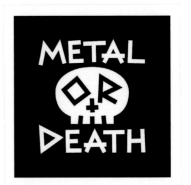

.84

.85

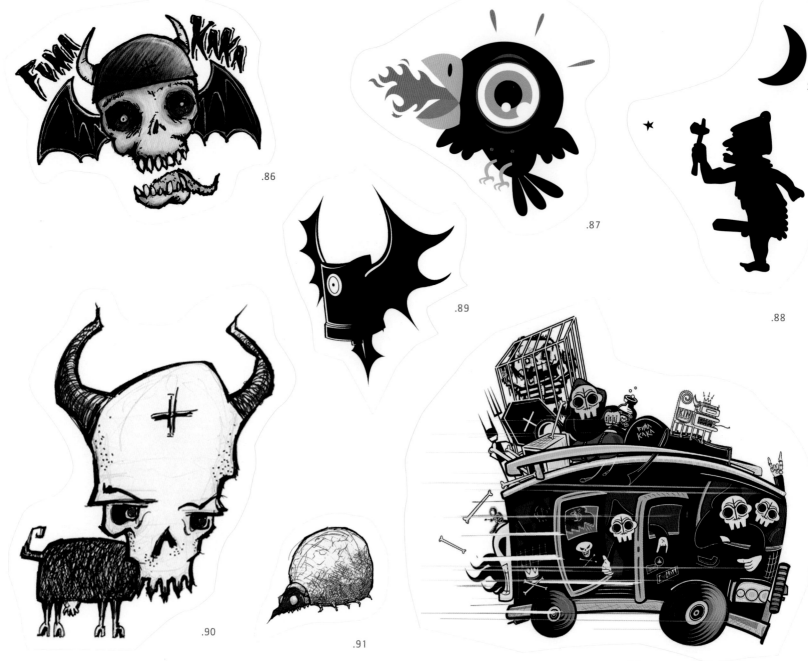

.86

.87

.88

.89

.90

.91

.92

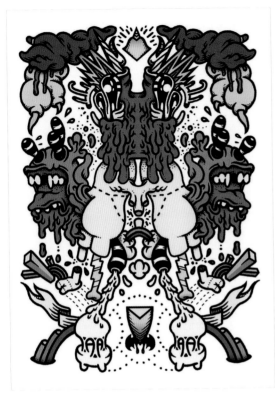

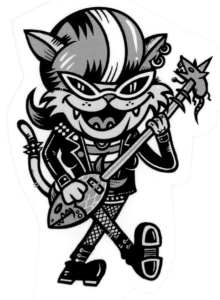

.93

.94

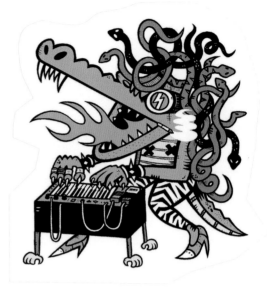

.95

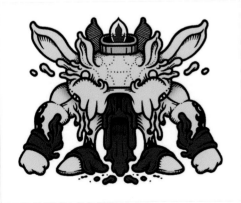

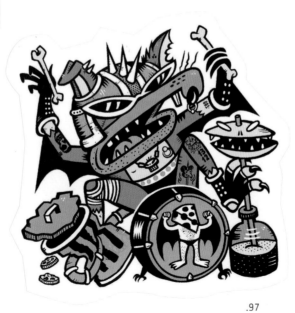

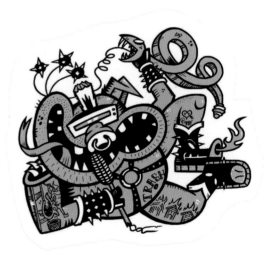

.96

.97

.98

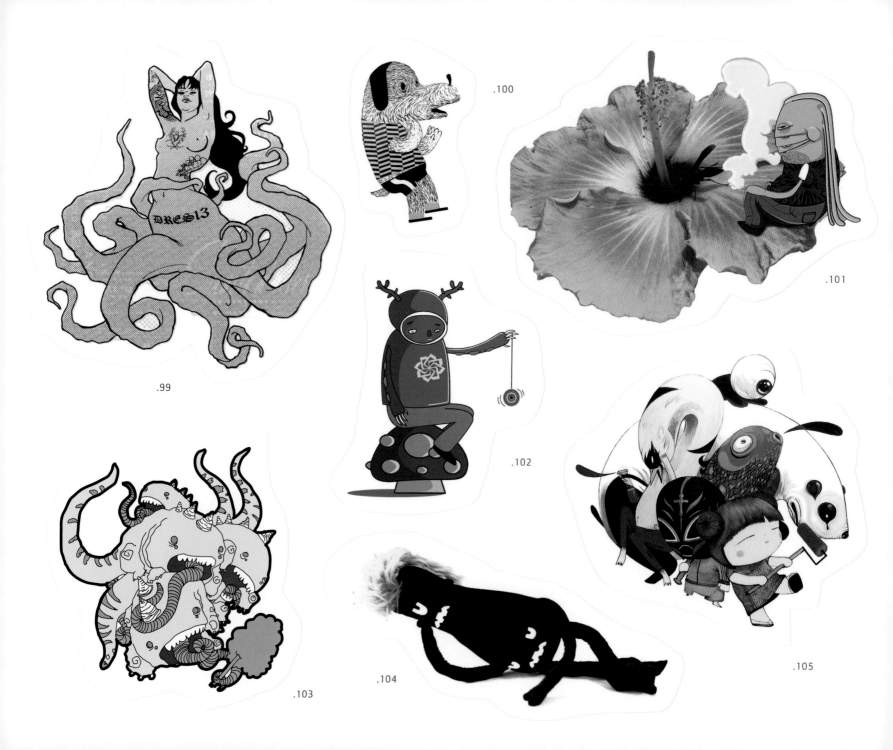

.99

.100

.101

.102

.103

.104

.105

.106

.109

.110

.107

.111

.108

.112

.113

.114

.115

.116

.117

.118

.119

.120

.121

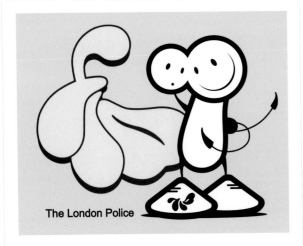

The London Police

.122

ROOTS PEOPLE
A BATIDA DA FLORESTA
CUSCO

.123

.124

.125

.128

.126

.127

.129

.130

.131

.132

.134

.135

.133

.136

.137

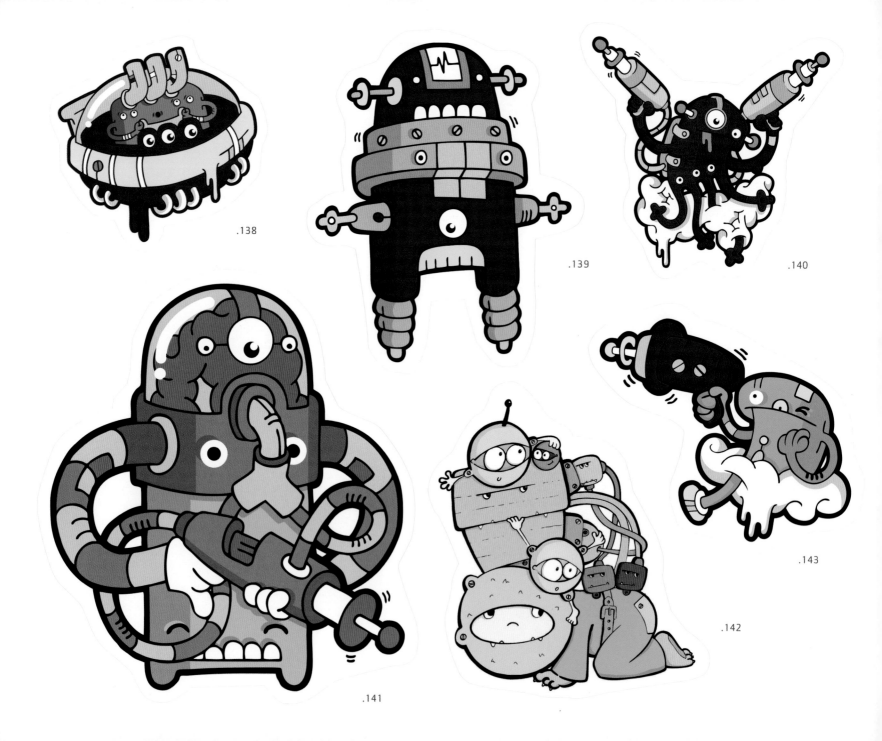

.138

.139

.140

.141

.142

.143

.144

.145

.146

.147

.148

.149

.150

.151

.152

.159

.160

.153

.154

.155

.161

.156

.157

.158

.162

.163

.165

.164

.166

.167

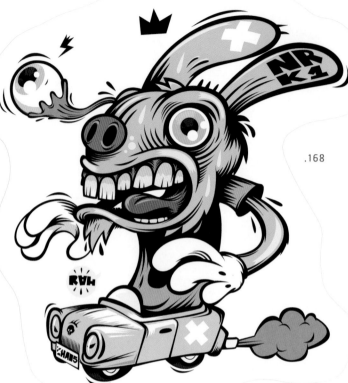

.168

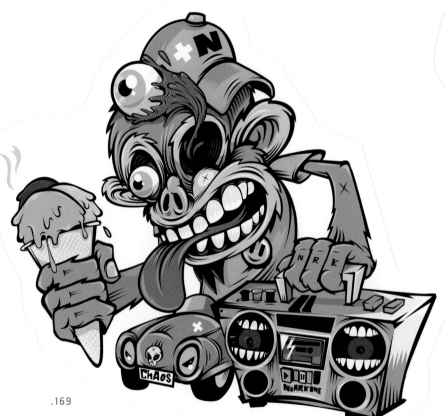

.169

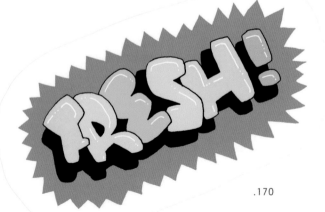

.170

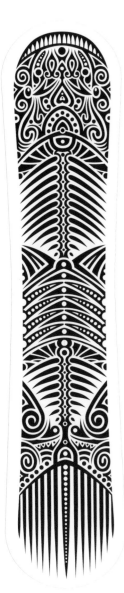

.171

.172

.173

.174

.175

.176

.177

.178

.179

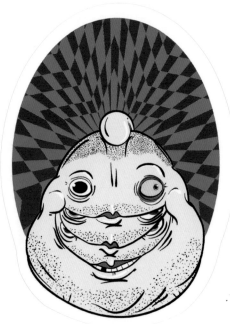

.180

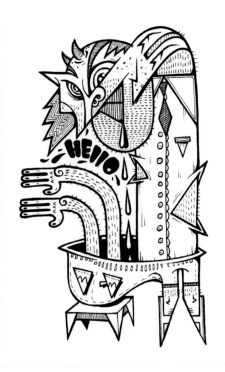

.181

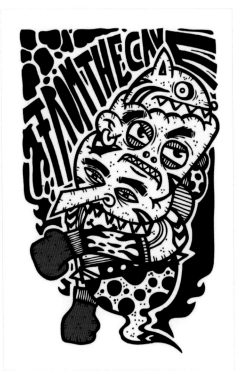

.182

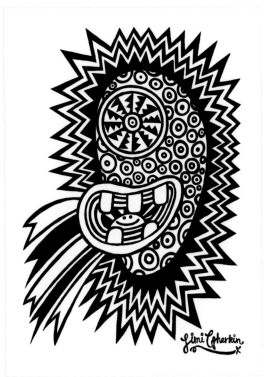
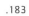

.183

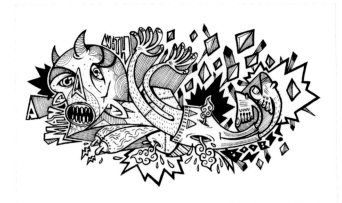

.184

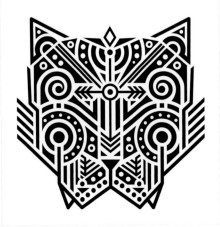

.185

.186

TAGGER
SCUM

.187

.188

.189

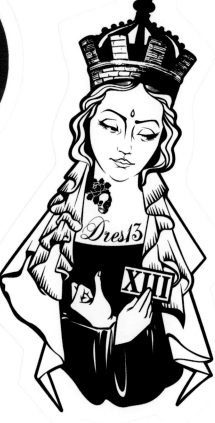

Dres13

XIII

.190

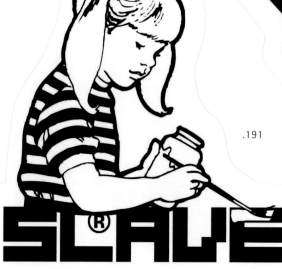

SLAVE

.191

.192

.193

.194

.195

.196

.197

.198

.199

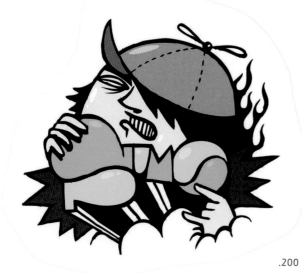

.200

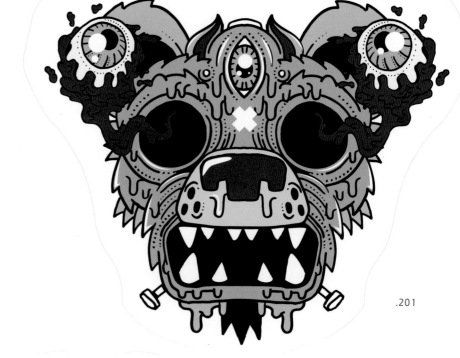

.201

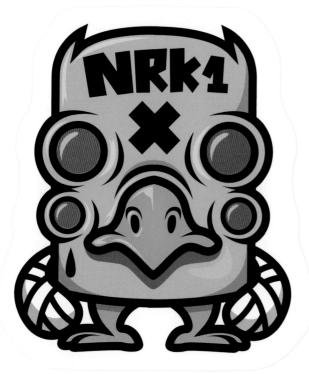

.202

.203

.204

.205

.206

.207

.208

.209

.210

.211

.212

.213

.214

.215

.216

.217

.218

.219

.220

.221

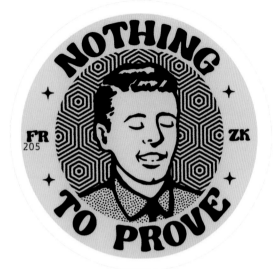

.222

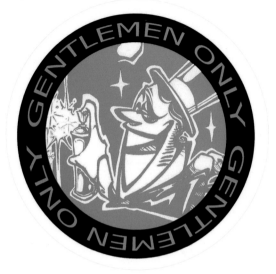

.223

.224

.225

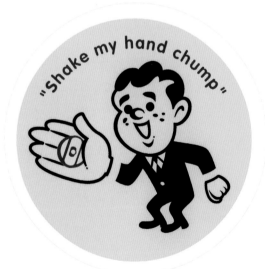

.226

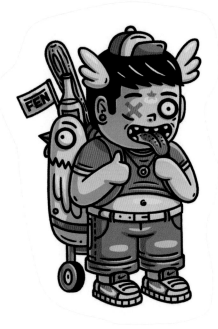

.227

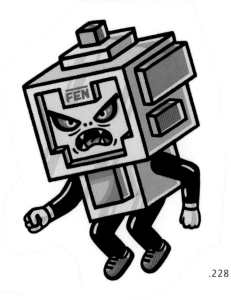

.228

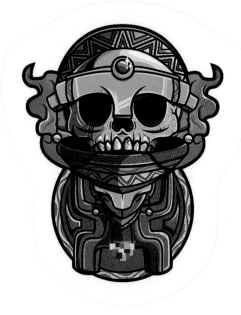

.229

.230

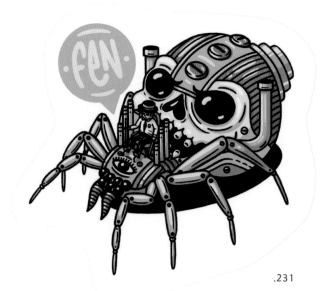

.231

.232

.233

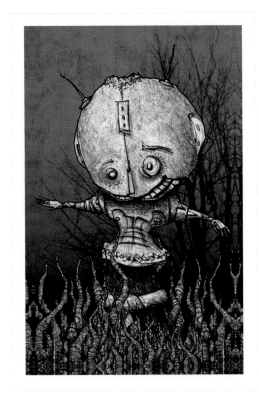

.234

.235

.236

.237

.238

.239

.240

.241

.242

.243

.244

.245

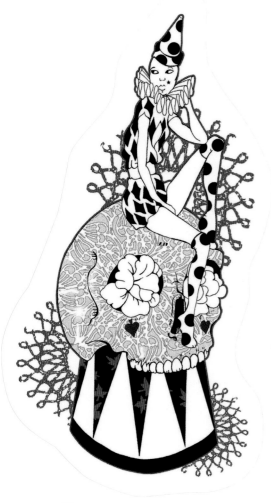

.246

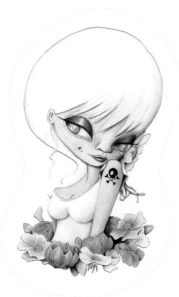

.247

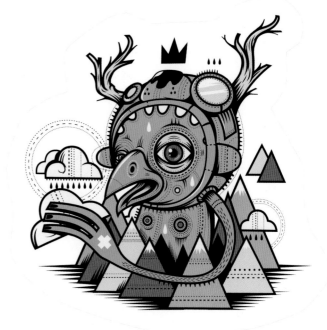

.248

.249

.250

.251

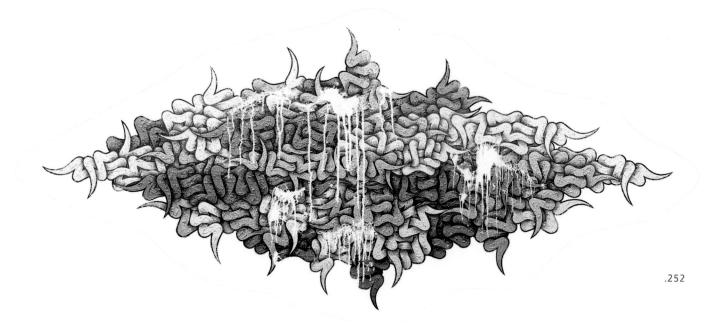

.252

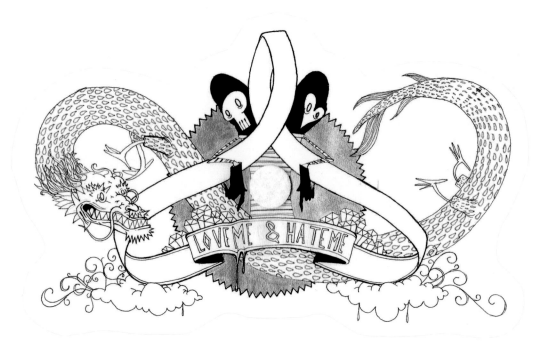

.253

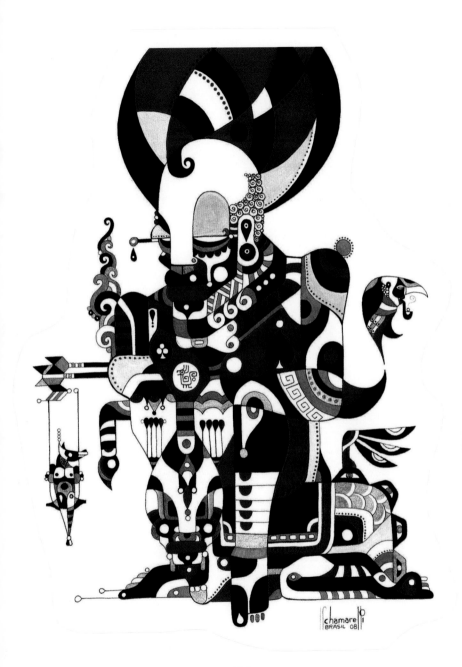

.254

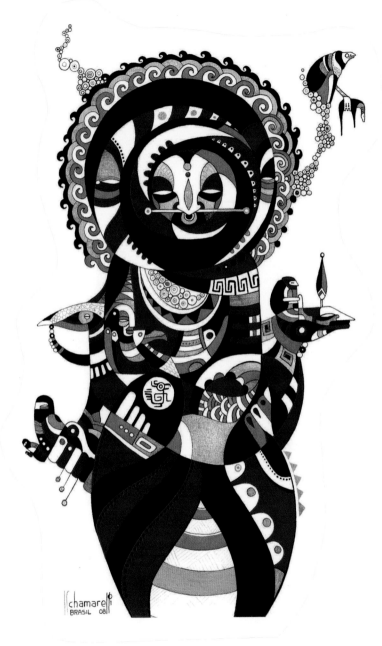

.255

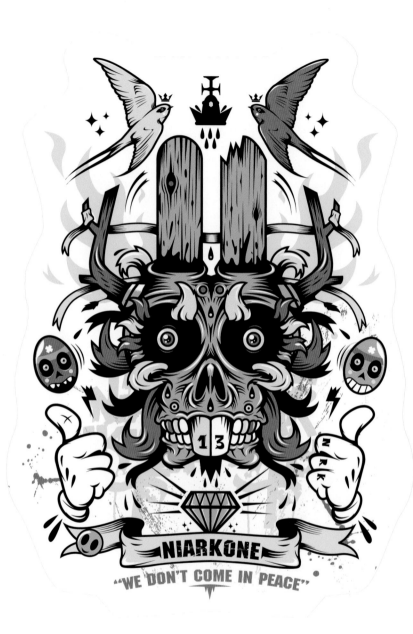

NIARKONE

"WE DON'T COME IN PEACE"

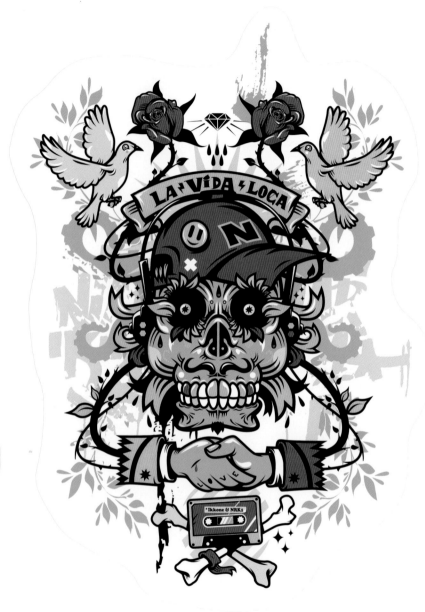

LA VIDA LOCA

.258

.259

.260

.261

.262

.263

.264

.265

.266

.267

.268

.269

.270

.271

.272

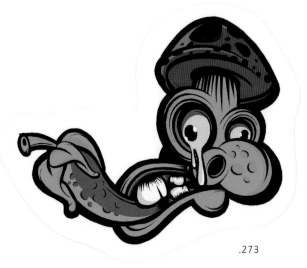

.273

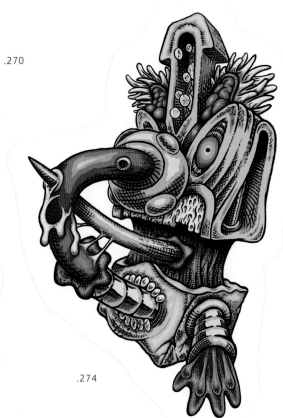

.274

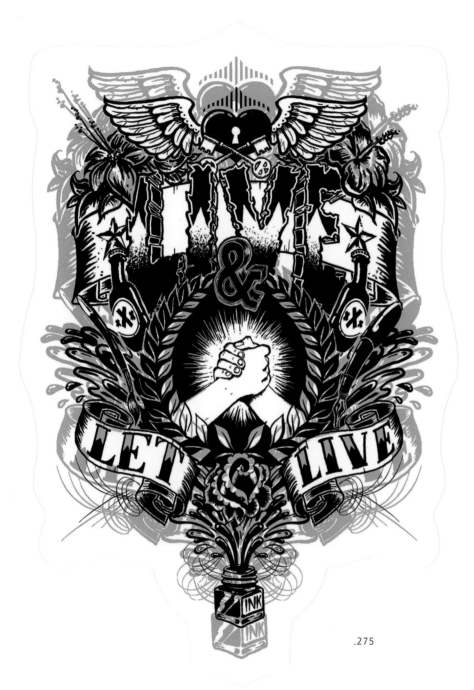

.275

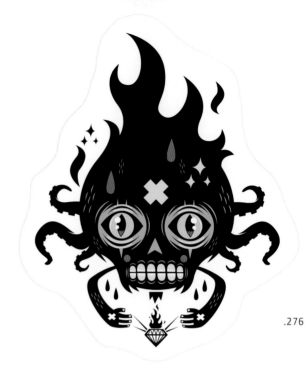

.276

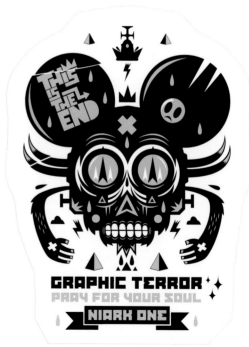

GRAPHIC TERROR
PRAY FOR YOUR SOUL
NIARK ONE

.277

.278

.279

.280

.281

.282

.283

.284

.285

.286

.287

.288

.289

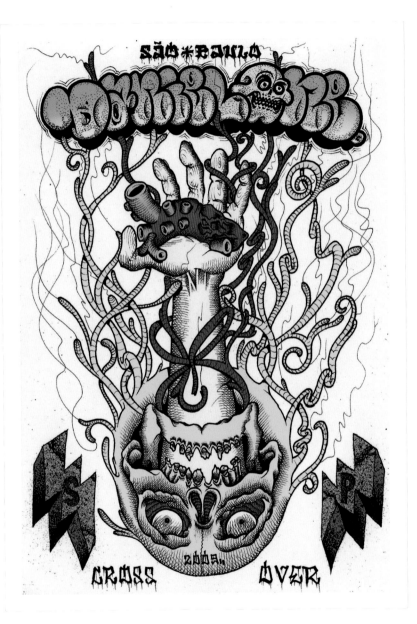

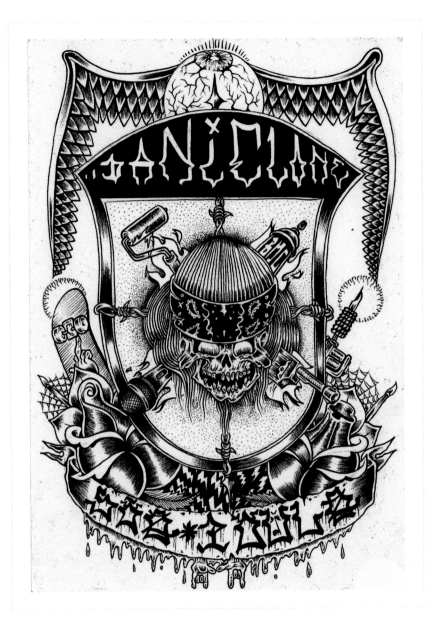

.290

.291

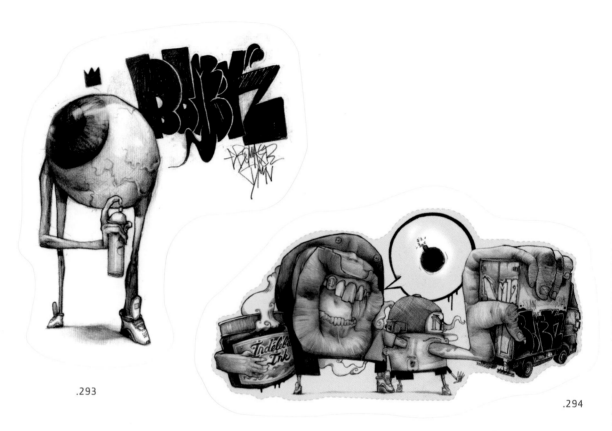

.292

.293

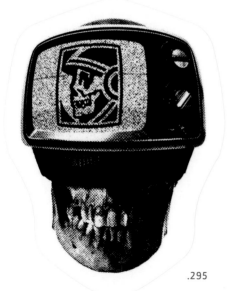

.294

.295

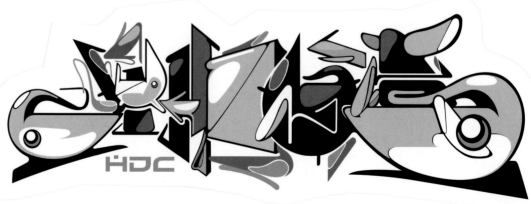

.296

.297

.298

.299

.300

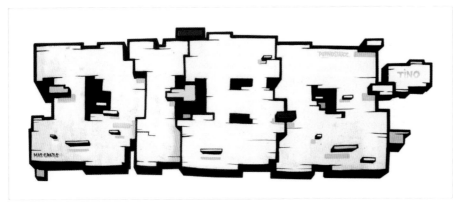

.301

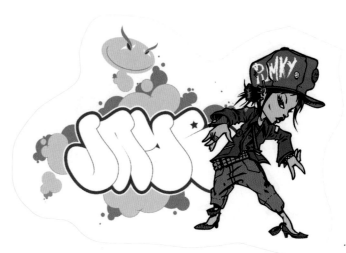

.302

.303

.304

.305

.306

.307

.308

.309

.310

.311

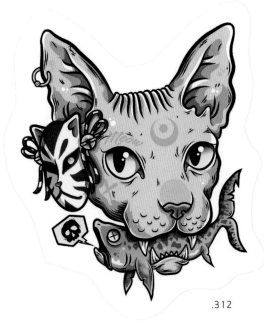

.312

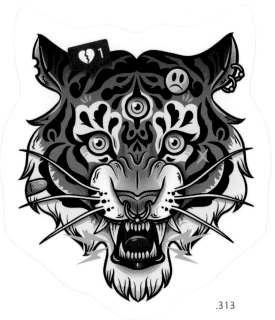

.313

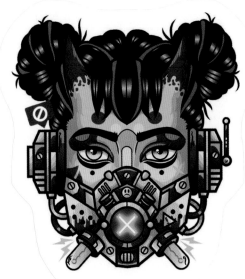

.314

.315

.316

.317

.318

.319

.320

.321

.322

.323

.324

.325

Sticker Index

.162 - Yok
.163 - Derek Deal
.164 - Derek Deal
.165 - Jeff Jank
.166 - Derek Deal
.167 - Choco Seven
.168 - Niark1
.169 - Niark1
.170 - Kid Acne
.171 - Matacho Descorp
.172 - Matacho Descorp
.173 - Matacho Descorp
.174 - Matacho Descorp
.175 - Tabas
.176 - Tabas
.177 - El Gato Chimney
.178 - Tabas
.179 - Tabas
.180 - Goms
.181 - Paulo Ferreira Tosco
.182 - FromTheCave | Caver
.183 - Jimi Gherkin
.184 - Paulo Ferreira Tosco
.185 - Matacho Descorp
.186 - The Paintly Store
.187 - Crok One
.188 - The Spaghettist
.189 - Slave
.190 - Dres13
.191 - Slave
.192 - Cute
.193 - Carlos Soto "Dundo"
.194 - Carlos Soto "Dundo"
.195 - Carlos Soto "Dundo"
.196 - Carlos Soto "Dundo"
.197 - Negativa Day-z
.198 - Negativa Day-z
.199 - Carlos Soto "Dundo"
.200 - Sumo
.201 - Niark1
.202 - Niark1

.203 - Niark1
.204 - Niark1
.205 - Dan Lish
.206 - Dan Lish
.207 - Dan Lish
.208 - Fernando Luque
.209 - Dan Lish
.210 - Flame
.211 - Scarlett (Kate Lightfoot)
.212 - Ben Newman
.213 - Jesse Green
.214 - Matt Buchanan
.215 - Esty Gertzman
.216 - Esty Gertzman
.217 - Ceito ATV
.218 - Ceito ATV
.219 - Esty Gertzman
.220 - Matt Buchanan
.221 - Derm
.222 - Ferizuku
.223 - Mutha
.224 - Ferizuku
.225 - Drao
.226 - Nishant Choksi
.227 - Fen
.228 - Fen
.229 - Fen
.230 - Fen
.231 - Fen
.232 - Iloobia
.233 - Radical!
.234 - Iloobia
.235 - Radical!
.236 - Radical!
.237 - Radical!
.238 - 0331C
.239 - 0331C
.240 - Kid Acne
.241 - Kid Acne
.242 - Pref
.243 - FromTheCave | Caver

.244 - Kid Acne
.245 - Kid Acne
.246 - Flame
.247 - Scarlett (Kate Lightfoot)
.248 - Niark1
.249 - Escif
.250 - Escif
.251 - Scarlett (Kate Lightfoot)
.252 - The Spaghettist
.253 - Escif
.254 - Fernando Chamarelli
.255 - Fernando Chamarelli
.256 - Niark1
.257 - Niark1
.258 - Imaone
.259 - Eatcho
.260 - The Krah
.261 - Mutha
.262 - Cusco Soul Rebel
.263 - Cute
.264 - YUP - Paulo Arraiano
.265 - Manito
.266 - Manito
.267 - YUP - Paulo Arraiano
.268 - Manito
.269 - Zeke Clough
.270 - YUP - Paulo Arraiano
.271 - YUP - Paulo Arraiano
.272 - YUP - Paulo Arraiano
.273 - YUP - Paulo Arraiano
.274 - Zeke Clough
.275 - Sam Bevington
.276 - Niark1
.277 - Niark1
.278 - Sat One
.279 - Germán Bertino
.280 - Germán Bertino
.281 - Delme
.282 - Gutface
.283 - Gutface
.284 - Otto Free Mind

.285 - Otto Free Mind
.286 - Otto Free Mind
.287 - Otto Free Mind
.288 - Otto Free Mind
.289 - Otto Free Mind
.290 - Daniel Cacciatore Angelucci
.291 - Daniel Cacciatore Angelucci
.292 - Stormie Mills
.293 - Bom.K
.294 - Bom.K
.295 - Proheroes 015
.296 - Suiko
.297 - K12NE
.298 - Tekno aka Egypt
.299 - K12NE
.300 - Tekno aka Egypt
301 - Dibo
302 - Jaye Nilko
303 - Suiko
304 - Suiko
305 - Suiko
306 - Suiko
307 - Suiko
308 - Suiko
309 - Inzano
310 - Inzano
311 - Inzano
312 - Inzano
313 - Inzano
314 - Inzano
315 - Dezio
316 - Asure
317 - Leet
318 - Mint&Serf
319 - Panik
320 - Ortus
321 - Ortus
322 - Garavato
323 - Garavato
324 - Ortus
325 - Ortus

Artist Index

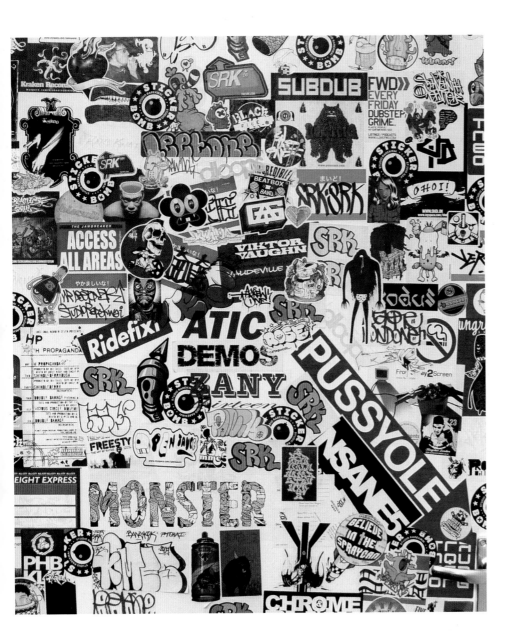

The SRK (2010) thanked Laurence King, Jo Lightfoot, Ben Ellsworth, Arno, Solo One, Remi, Rarekind, Diego Medina, Jeff Jank, El Gato Chimney, Dezio, Pez, Darbotz, ATG, Jesse, Open Sauce, 5MM and Iloobia.

In 2024, we'd like to add Elen Jones, Laura Paton, Felicity Awdry, September Withers and Steve Aston.

RIP Orkibal and RIP Bytedust.

Big thanks as ever to Laurence King.

Soi Books 2024

@bombstagram / @soico.xyz
www.stickerbombworld.com / www.soibooks.com